THE
TERRACOTTA
WARRIORS

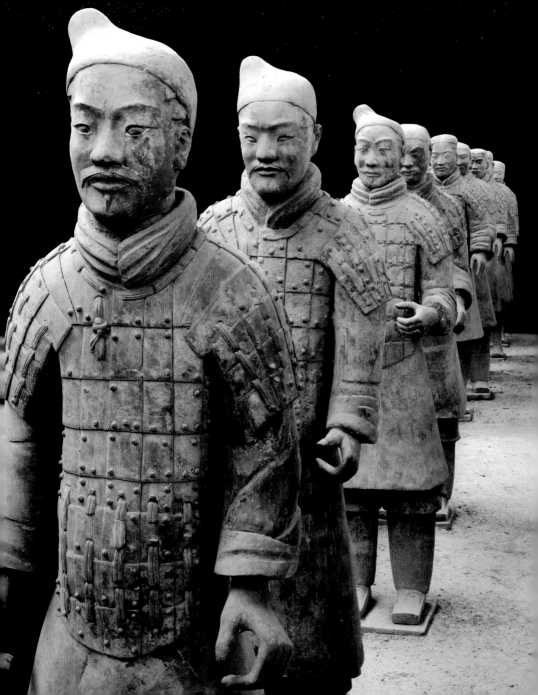

THE
TERRACOTTA
WARRIORS

JANE PORTAL

PHOTOGRAPHS BY JOHN WILLIAMS AND SAUL PECKHAM

THE BRITISH MUSEUM PRESS

For Peter

First published in 2007 by The British Museum Press
A division of The British Museum Company Ltd
38 Russell Square, London WC1B 3QQ
www.britishmuseum.co.uk

ISBN-13: 978-0-7141-2450-6

New photography by John Williams and Saul Peckham
© The Trustees of the British Museum, with the kind permission
of the Shaanxi Cultural Heritage Promotion Center
Designed and typeset by Price Watkins
Printed in Spain by Grafos SA, Barcelona

Frontispiece Armoured infantrymen lined up in Pit 1. They would
originally have been holding real bronze weapons.

CONTENTS

THE TERRACOTTA ARMY OF THE FIRST EMPEROR

The terracotta army of the First Emperor of China was discovered by surprise in 1974. Since then, millions of visitors have marvelled at it in the on-site museum opened in 1979. It is evidence of the vision and organizational power of Qin Shihuangdi, the First Emperor of the Qin dynasty, who unified China in 221 BC. Archaeologists predict that excavations at the site of the tomb of the First Emperor will keep them busy for generations, as new discoveries are made year by year and new techniques of conservation and scientific research are introduced and perfected. In fact, it will doubtless take longer to excavate the First Emperor's tomb complex than the approximately thirty-six years it took to build it.

The tomb site on the outskirts of present day Xi'an had been known for thousands of years from the Chinese written record, and the tomb mound in the shape of a square, flattened pyramid had long been visible above ground. However, the terracotta army came as a complete surprise to all, because there was no record of it. The tomb itself was described in some detail by Sima Qian, the official historian of the dynasty that overthrew and followed the First Emperor's; there was no mention of an underground army. Also, the fact that the pits containing the terracotta army were at such a distance from the mound itself demonstrated the huge scale of the underground tomb complex. They are located 1.5 km east of the tomb mound, and the whole tomb complex area is now estimated to cover over 50 sq. km. This is the largest and most important tomb site in China.

OPPOSITE
Terracotta figure of a general excavated from Pit 1.

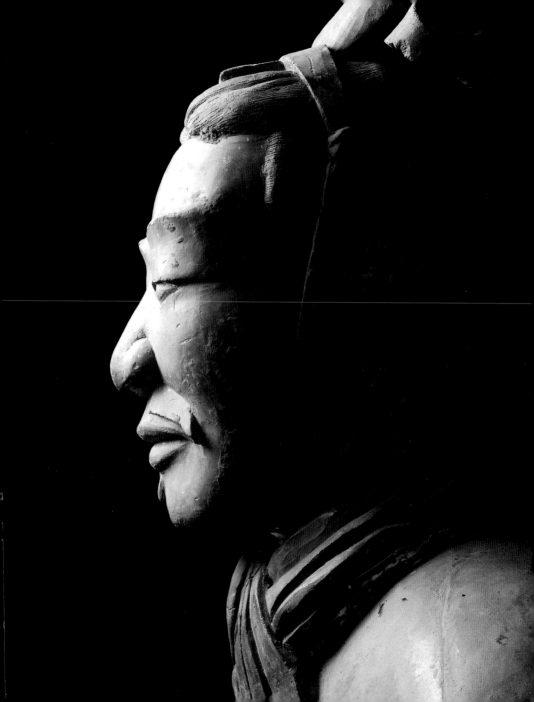

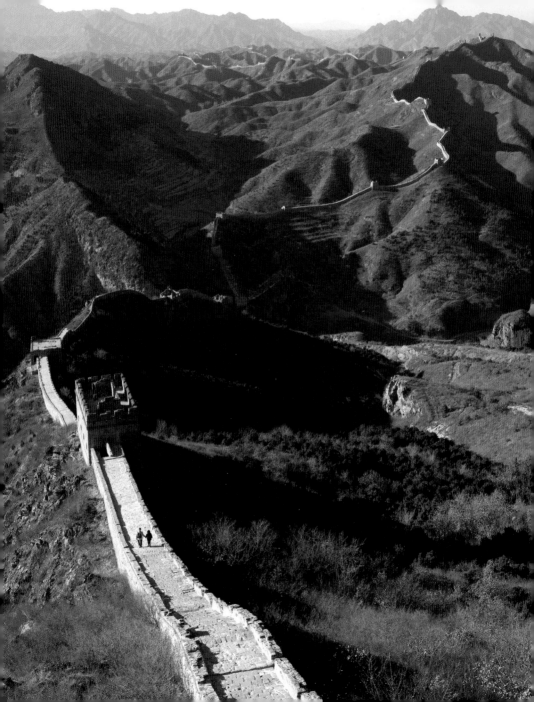

The First Emperor of China

King Zheng of Qin was born in 259 BC and became King of the state of Qin in 246 BC when he was only thirteen. By the time he was thirty-eight, he had unified the 'Warring States' and taken the name Qin Shihuangdi or Great August First Emperor of Qin. Before the First Emperor's time, China was for hundreds of years divided into different states or kingdoms, many of which were at war with each other over various periods. The state of Qin, situated in the far west of China, was a poor and rather frugal state. However, it gradually adopted technology from other states and developed weapons and military technology until it was pre-eminent in these areas. It was never as rich or culturally developed as, for example, the state of Chu in the south, but it was better organized and succeeded in gradually conquering all the different states.

The First Emperor then ordered General Meng Tian to complete the construction of the Great Wall by joining together existing sections built by other states. It was made of tamped earth during the Qin dynasty and was not the same as the present-day wall, which was built of brick later in the Ming dynasty (1368–1644). The *Records of the Grand Historian*, written by Sima Qian in the following Han dynasty (206 BC–AD 220), notes: 'He built a Great Wall, constructing its defiles and passes in accordance with the configuration of the terrain. It started at Lintao and extended to Liaotung, reaching a distance of more than 10,000 li. After crossing the Yellow River, it wound northward touching the Yang mountains.' A major communications system was also built by Meng Tian for the First Emperor, which has been estimated to total 6,800 km of highways.

Before the First Emperor unified China, in the time called the Warring States period (475–221 BC), itinerant philosophers would travel from state to state advising the rulers. Confucius, Mencius and Laozi are perhaps the most

LEFT
The Great Wall we see today is not the wall completed under the First Emperor. It is made of brick and was built in the Ming dynasty. The Qin Great Wall was made of compressed earth; some parts still remain today.

famous of these philosophers, founders of what later came to be known as Confucianism and Daoism. The First Emperor rejected Confucianism and adopted the Legalist philosophy, introducing a new law code with its emphasis on rewards and punishments. He also presided over the unification of the coinage system, the standardization of weights and measures, and the script. He moved 120,000 families of aristocrats from defeated states to his capital at Xianyang, near to present day Xi'an, where he built palaces copying their original ones, as well as the massive Ebang Palace. He also travelled around the country he had conquered, carrying out sacrifices and setting up inscriptions on stelae proclaiming his achievements and declaring himself ruler of the entire universe. One of the inscriptions reads:

> Great is the virtue of our Emperor
> Who pacifies all four corners of the earth,
> Who punishes traitors, roots out evil men
> And, with profitable measures brings prosperity.
> Tasks are done at the proper season,
> All things flourish and grow;
> The common people know peace
> And have laid aside weapons and armour;
> Kinsmen care for each other,
> There are no robbers or thieves;
> Men delight in his rule
> All understanding the law and discipline.
> The universe entire
> Is our Emperor's realm...

Qin Shihuangdi tried very hard to avoid dying and sampled many different potions created for him by alchemists at Court; these may have included mercury. It is thought that when he eventually died, during a tour in the east of his empire, it may have been from mercury poisoning. It is written that smelly salted fish had to be put in a covered carriage with his body as it was transported back to Xianyang, so that no one knew of his death. His Chief Minister Li Si needed time to ensure the succession.

From the time that he became King of the Qin state in 246 BC, he started the construction of his tomb complex. When he became Emperor in 221 BC, the design for his tomb seems to have been expanded. Large numbers of conscripts were put to work on the project, as the military campaigns had come to an end. It was unfinished when he died suddenly in 210 BC. We infer this because one of the terracotta army pits was found empty. Today a large tumulus occupies the centre of the tomb compound, and the artificial hill, planted with bushes and trees, has the shape of a truncated pyramid; its base approximately 350 sq. metres.

The Army and its Manufacture

The terracotta army is buried in four pits located to the east of the tomb mound and outside the walls of the tomb complex. It is as if it were placed there to guard the tomb from attack from the east, where all the conquered states lay. Pit 1, 230 metres long, contains the main army, estimated at more than 6,000 figures. Pit 2 has cavalry and infantry units as well as war chariots and is thought to represent a military guard. Pit 3 is the command post, with high-ranking officers and a war chariot. Pit 4 was empty, probably left unfinished by its builders. Together, the four pits seem to represent a complete garrison and the total number of warriors and horses is estimated at about 8,000. All the warriors originally carried life-size real weapons, which disappeared when the pits were looted and burned in the rebellions after the death of the First Emperor.

It is perhaps the enormous scale of the terracotta army as well as the quality of the representation and manufacture of its conscripts that continue to move visitors so greatly. These mature, life-size sculptures seemed to have appeared out of nowhere as there was no tradition of such large or such realistic sculptures in the centuries preceding the Qin. Although the warriors have been described by some as individual portraits in clay of actual soldiers, it has now been shown that the manufacture of the army was a great and early feat of mass-production: a small and quite limited repertoire of body parts was produced

OVERLEAF
View of Pit 1 showing terracotta warriors lined up ready to guard the First Emperor's tomb.

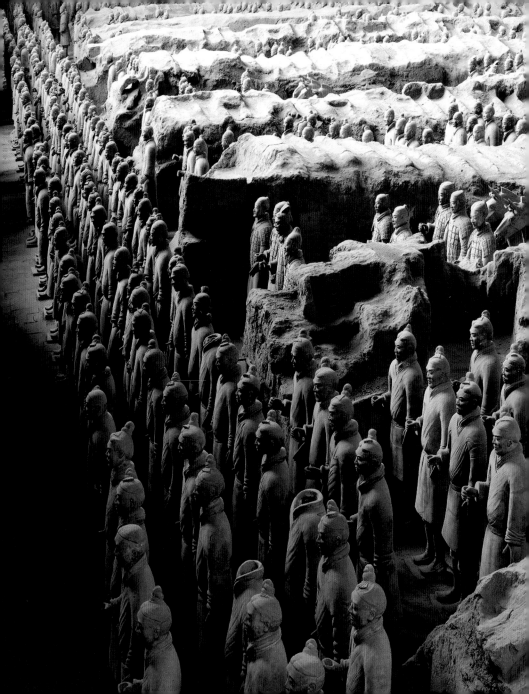

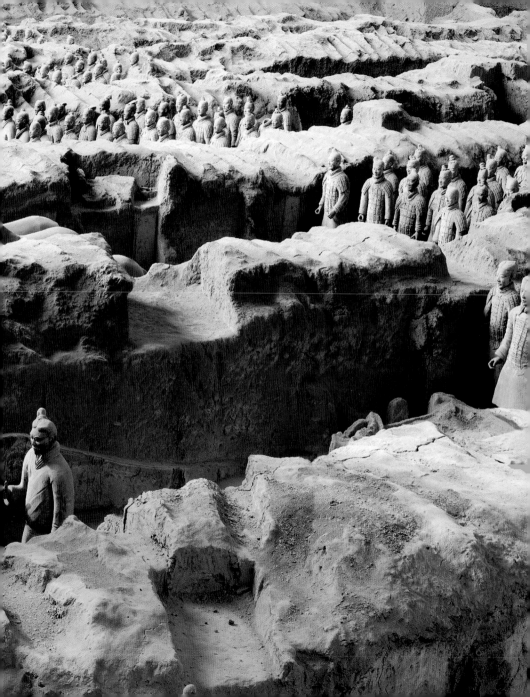

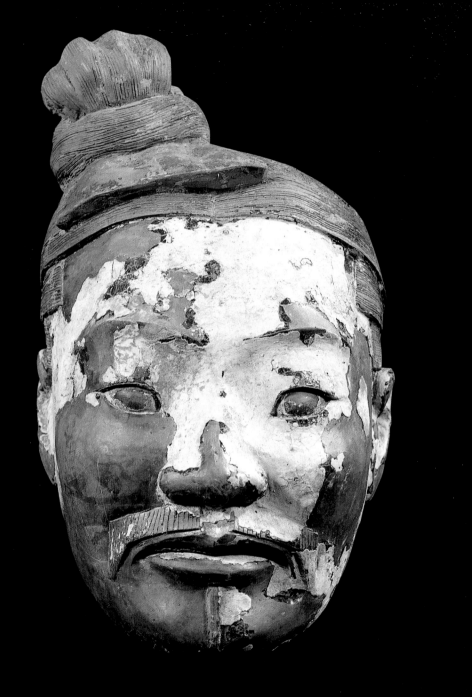

using moulds, coiling and slab building. They were joined together in a multitude of combinations, with details worked by hand afterwards before the whole figure was painted. Endless variety – for example, of costumes, hairstyles, hand positions or facial features – was therefore possible. Warriors were stamped with the name and unit of the foreman, in order to ensure quality control. Some of the names match those of inscriptions on floor tiles and drainpipes found near the mausoleum. This suggests that architectural ceramic workers were most probably responsible for the terracotta army, which would explain the construction methods; ankle joints were fixed with pins or pegs, for example. Moulds, using the local loess or yellow earth, had been in use for hundreds of years, not only for making roof tiles but also in the production of bronzes during the earlier Shang and Zhou dynasties. It has been estimated that over a thousand people may have been involved in the making of the terracotta army. The fact that there is no written description of it in the later historical record suggests that it must have been kept secret. Many of the labourers probably died of overwork, or were perhaps buried with the results of their labours.

It is not universally understood that the warriors were originally brightly painted, both their costumes and their bodies. The colour pigments were mixed with lacquer and applied after the firing of the terracotta figures. When excavated, the exposure to air resulted in the immediate loss of the colours. Over the last fifteen years, conservation work, carried out in co-operation with the German government, has resulted in new techniques being used to preserve some of the colours, which are surprisingly varied and vivid.

LEFT
Head of an infantryman excavated from Pit 1 showing the original pigment on the face.

The Tomb Complex Revealed

Since the discovery of the terracotta army, ongoing excavations have furthered our knowledge of the massive scale of the entire tomb complex. Remains of above-ground buildings have been found within the large tomb area, which is surrounded by two walls – an inner wall and an outer wall. These buildings were for acts of ritual and sacrifice. Excavations following that of the terracotta army have unearthed other pits around the tomb mound itself, which is still unexplored. One of these contains human skeletons with severed limbs, perhaps representing people sacrificed in religious rituals. Another has rare birds and animals in rows of clay coffins, with clay dishes for food and collars attached to the animals. There are many pits containing horse skeletons and terracotta grooms, possibly portraying an imperial stable. More than one hundred human skeletons have also been found in mass graves and are perhaps those of conscript workers.

In 1980 two magnificent, painted bronze chariots were excavated, each half life-size and drawn by four horses, for the First Emperor to use for inspection tours in the afterlife. Consisting of over 3,000 parts, they show the techniques of chariot building and horse harnessing in great detail. Large quantities of hay were deposited in the pit for the horses, underlining an interesting feature of the First Emperor's tomb – the mixture of the real and man-made. Real people and animals were buried as well as terracotta and bronze ones.

More recently, in the late 1990s, an intriguing find of hundreds of sets of grey stone armour, including horse armour, was discovered in a large rectangular pit to the south-east of the tomb mound, over 13,000 sq. metres in size. It has puzzled scholars because, although this armour is carefully modelled on the leather and iron suits used in battle at this time, armour in stone is much too heavy to be practical and would have been useless protection against spearheads and arrows of bronze and iron – it would just have shattered. The most-likely explanation is that this armour was designed for repelling evil spirits. The famous jade burial suits that appear in the following Han dynasty were probably developed from this stone armour.

Since China is famous for inventing bureaucracy, it is appropriate that the First Emperor also felt the need for officials in his afterlife, as well as an army to

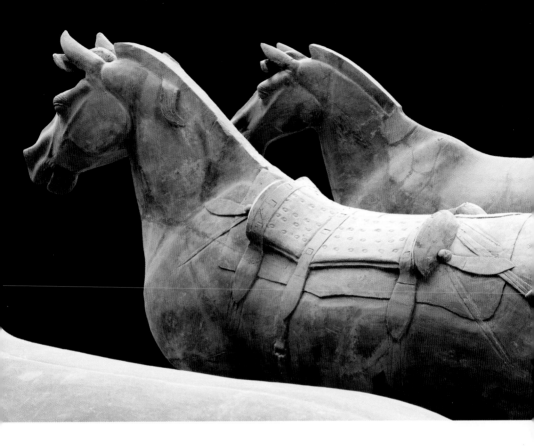

guard him. In late 2000 a group of terracotta civil officials and scribes came to light in a pit to the south-west of the tomb mound.

Entertainment was also provided for the emperor's afterlife: eleven terracotta acrobats and strongmen were found with a large bronze tripod on top in a pit to the south-east of the tomb mound. The most recent find, in August 2001, was that of an F-shaped pit, with a diverted underground river, containing terracotta musicians who were playing music to life-size bronze water birds.

ABOVE
Terracotta cavalry horses. Both real and man-made horses had roles to play in the First Emperor's afterlife universe.

The Tomb Mound

It is tantalizing that the actual tomb mound, which all the pits surround, has not yet been excavated. However, it was described about a hundred years after its construction by the Han-dynasty historian Sima Qian as follows:

> As soon as the First Emperor became king of Chin [Qin], excavations and building had been started at Mount Li, while after he won the empire more than seven hundred thousand conscripts from all parts of the country worked there. They dug through three subterranean streams and poured molten copper for the outer coffin, and the tomb was filled with models of palaces and pavilions and offices, as well as fine vessels, precious stones and rarities. Artisans were ordered to fix up cross-bows so that any thief breaking in would be shot. All the country's streams, the Yellow River and the Yangtse were reproduced in quicksilver and by some mechanical means made to flow into a miniature ocean. The heavenly constellations were shown above and the regions of the earth below. The candles were made of whale oil to ensure their burning for the longest possible time.

From this description, it is clear that the grandeur of the tomb plan was unsurpassed. The First Emperor's tomb complex is a microcosm of the universe, an analogue of the realm over which he had ruled and intended to continue to rule after his death. It also marks a change in the design of tombs in China: from shaft tombs to pits lined with wood and filled with boxes of grave goods and with ritual bronzes to chamber tombs that were seen as palaces for the use of the incumbent in the afterlife. Chinese archaeologists have so far decided not to excavate the actual tomb chamber, but are concentrating on the many pits surrounding it, awaiting future developments in excavation and conservation techniques as well as new ways of non-destructive scanning. As excavation proceeds in the areas around the tomb mound, the grand scale of the First Emperor's underground afterlife government is gradually revealed. The awe-inspiring terracotta army is just one part of the entire enterprise.

ABOVE
Tomb mound of the First Emperor, which has not yet been excavated.

OVERLEAF
Terracotta warriors as discovered in Pit 1, showing the results of the looting and burning of the pits following the First Emperor's death.

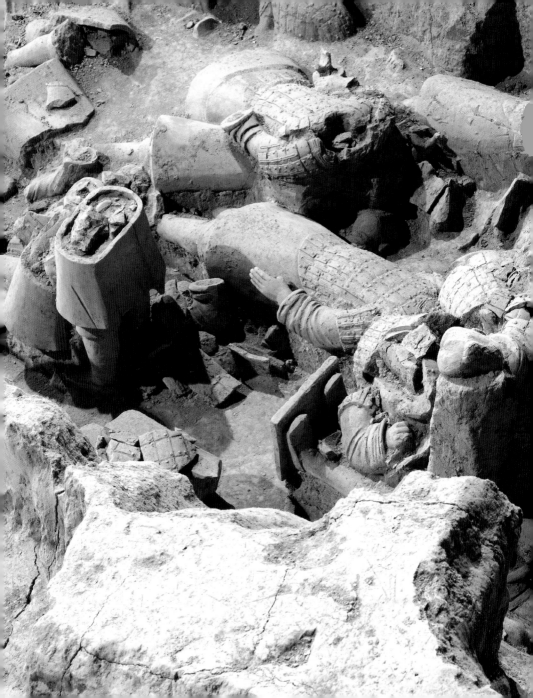

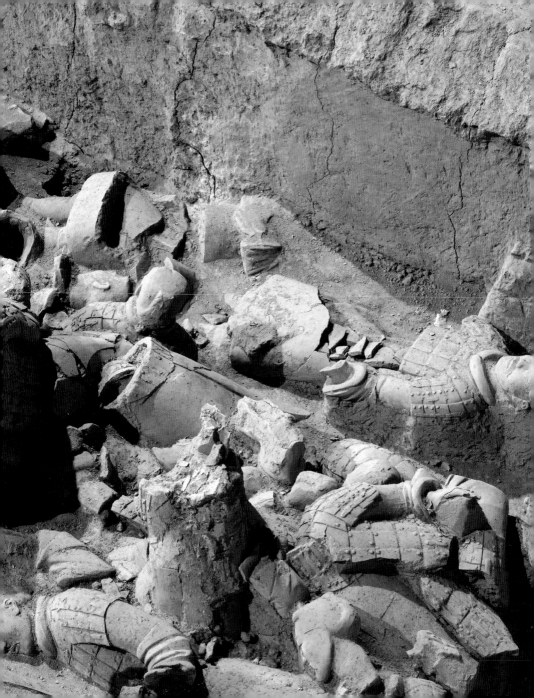

GENERALS

Generals are the highest-ranking officers found in the First Emperor's tomb complex. Armoured generals can be recognized by their long coats covered in a pointed flap of armour, beribboned uniform and unique winged caps which look like a bird with a double tail. Nine generals have been found so far and all have been near a command chariot. Some armoured generals have a hole under their left arm, which was probably for a scabbard from which they could draw the sword using their right arm. Fragments of pigment remain in places on some of the generals, so that we know that their long coats were green, the inner coat was white and the sleeves were lined in purple. The hems had painted decoration imitating a woven fabric with a diamond pattern on a purple ground. On the upper part of the body the painted decoration imitated a fabric decorated with pairs of birds, suns and geometric patterns in pale green on black.

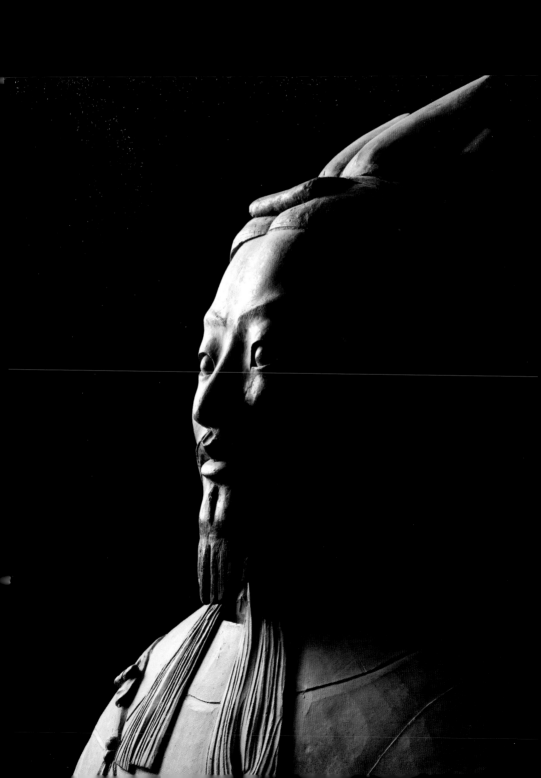

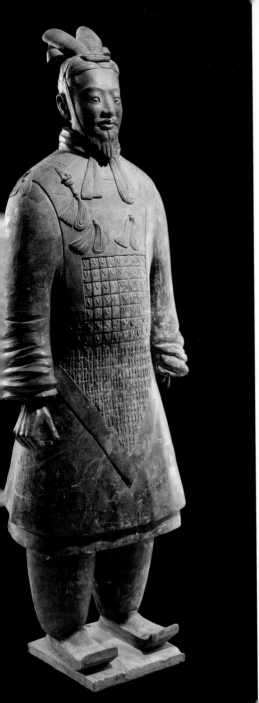

LEFT
Armoured general from Pit 1.
At 195 cm high, the generals
were some of the tallest figures
discovered. This height includes
the base plate and the hat.

RIGHT
Back view showing details of
the beribboned uniform and
overlapping armour panels
imitating lacquered leather.

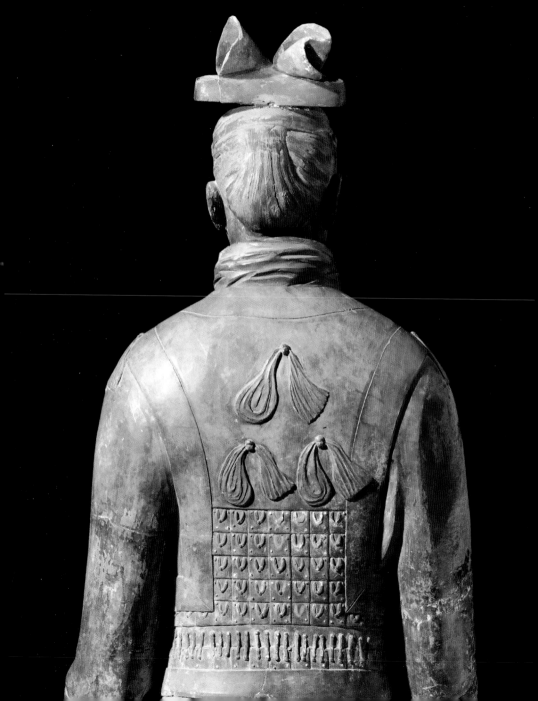

RIGHT
Unarmoured general. His face has high cheekbones
and a square jaw. It is clear how the moustache and
small beard were applied and worked by hand.

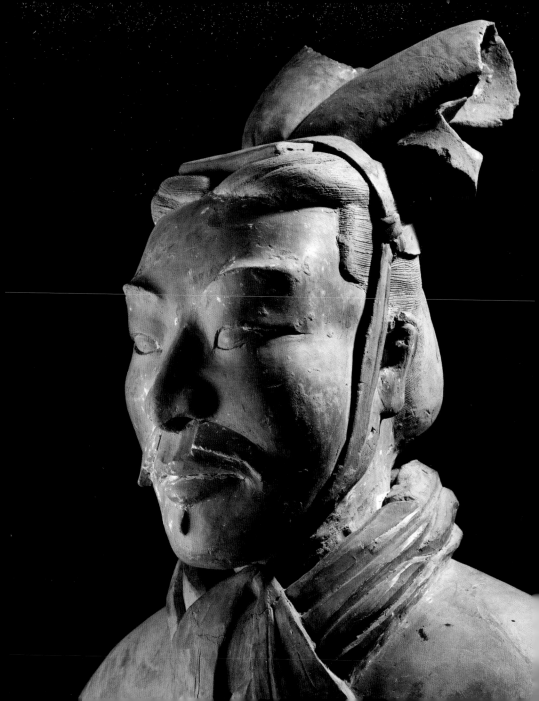

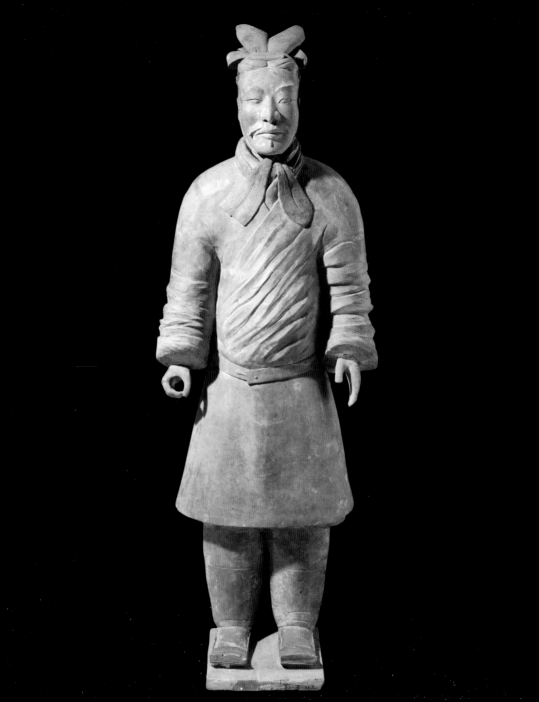

LEFT
The unarmoured general wears
a long coat and has a belt that is
held together by a belt hook,
imitating those known in bronze
from this period. His right hand is
clasped around a missing weapon;
he was probably originally holding
a sword. The folds of his robe on
the chest and the sleeves are
particularly realistically portrayed
and there is a great feeling of the
thickness of the cloth, perhaps
padded cotton.

RIGHT
Side view showing details of his hat
and its straps, as well as his plaited
and pinned-up hair. His profile also
displays his slight paunch and
protruding bottom, suggesting
that he was of a certain age.

OVERLEAF
The hat worn by generals and
high-ranking officers was called
the 'pheasant cap', on account of
its shape resembling double
wings. It was tied under the chin.

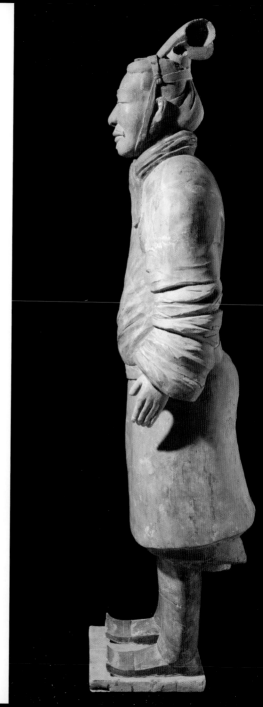

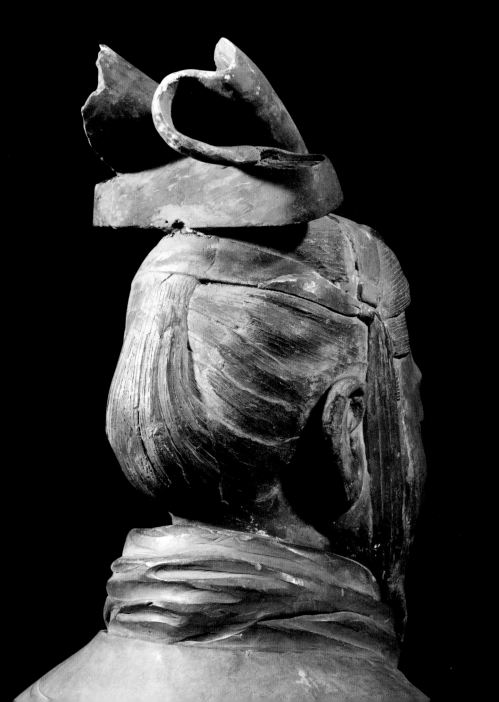

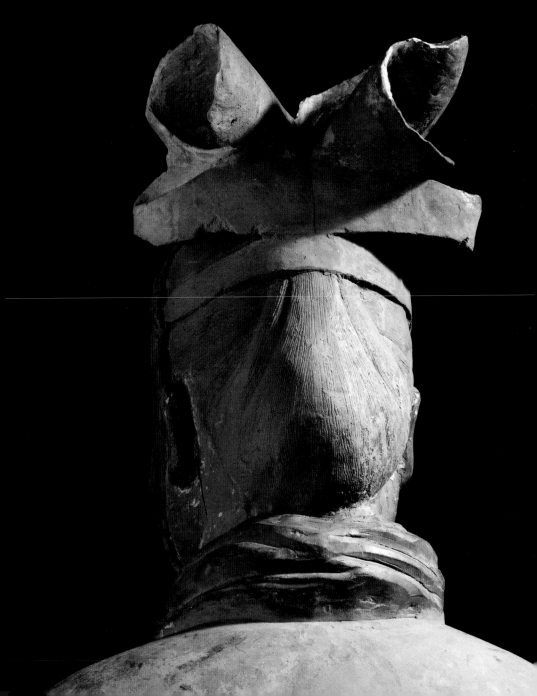

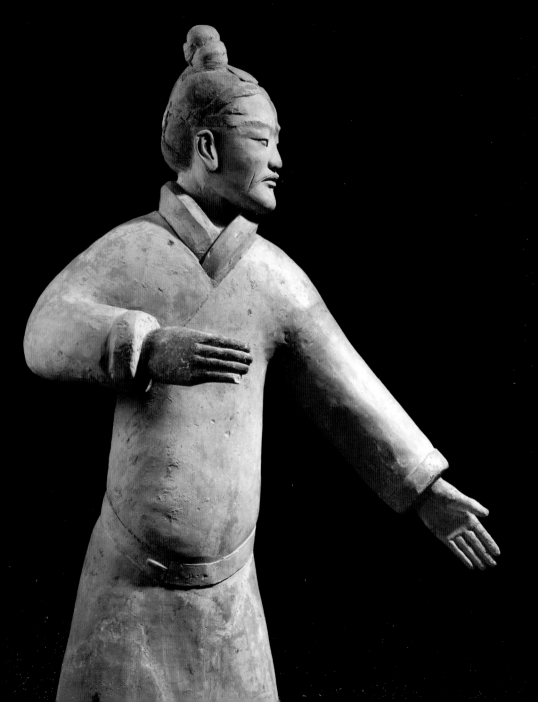

STANDING ARCHERS

This terracotta standing archer excavated from Pit 2 can be compared with the following kneeling archer. Here the archer seems to be lowering his bow, while the kneeling archer is loading his. The standing archers were unarmoured and would have given the Qin army speed and mobility. Their long robes were held together with a belt fastened by a belt hook. This figure is particularly slim and seems to have an expression of deep concentration on his task.

OVERLEAF
Details of the backs of the heads of the standing and kneeling archers illustrating their complicated hairstyles, which were finished by hand. The hair was tucked into a tilted topknot, the sides and back having been first plaited.

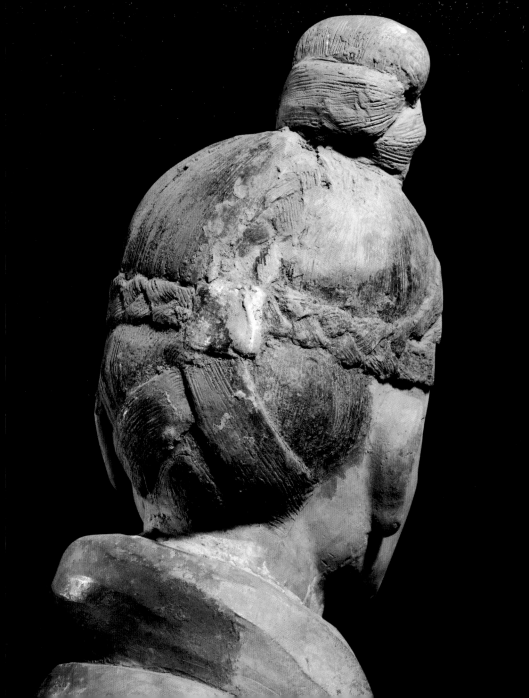

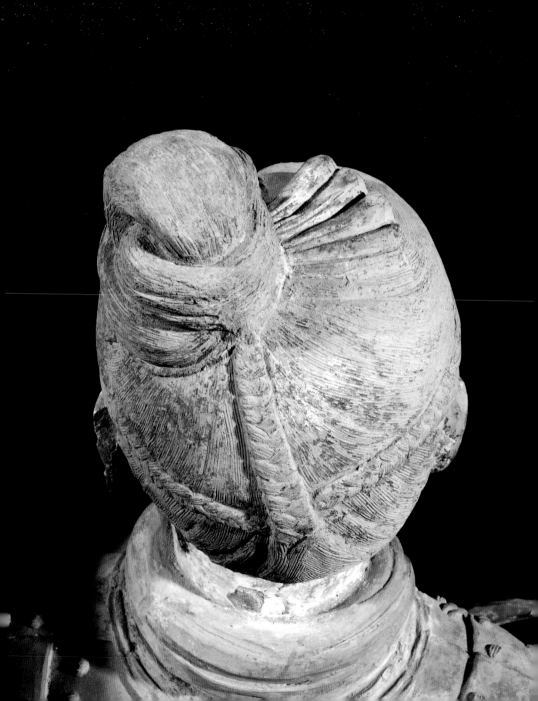

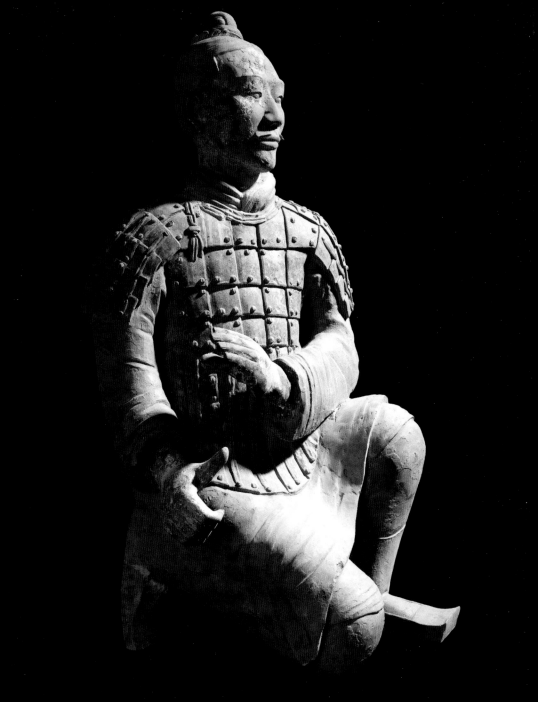

KNEELING ARCHERS

This kneeling archer from Pit 2 is heavily armoured, with overlapping panels protecting his chest, abdomen and shoulders. Crossbows would have permitted the archers to fire heavy bolts with great force and penetration over a longer distance and were said to require less skill and strength than the earlier composite bows. They were slower to load, but this could be compensated for by the rows of archers acting in unison, with the front line firing together while the line behind was rearming. Although the Qin did not invent the crossbow-trigger mechanism, it perfected and standardized its manufacture, which revolutionized military warfare.

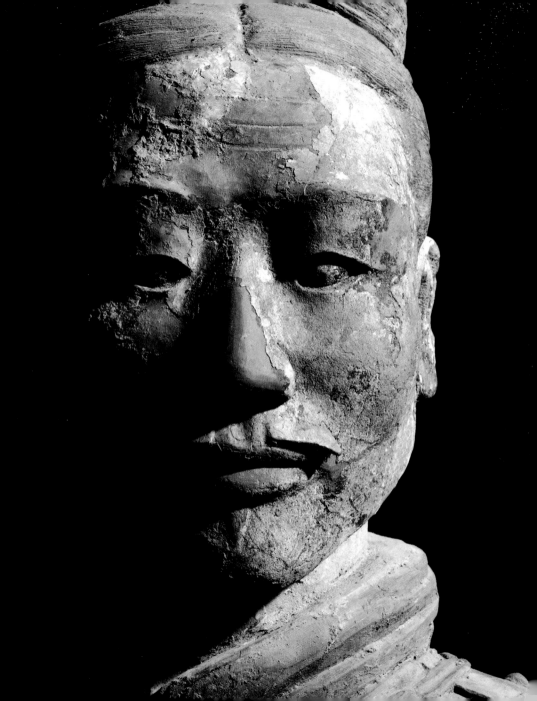

Traces of pigment can still be seen on the face of the kneeling archer.

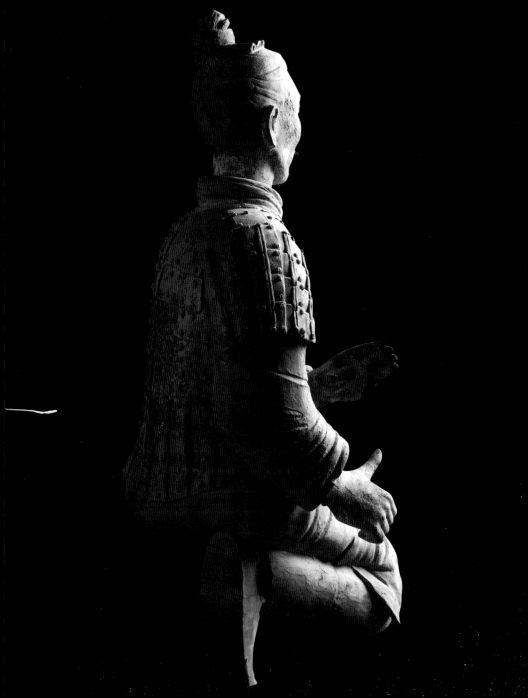

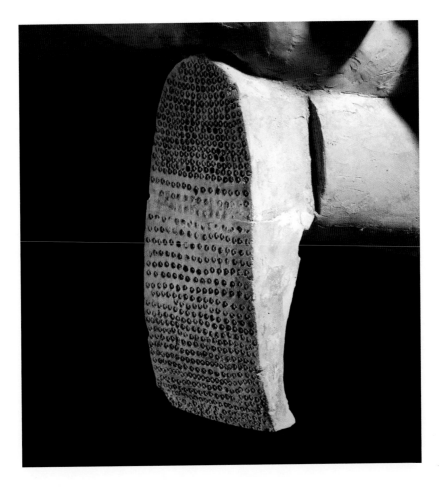

LEFT
Back view of kneeling archer.

ABOVE
The sole of the kneeling archer's shoe. Such attention to detail
shows the great control exercised over the workforce.

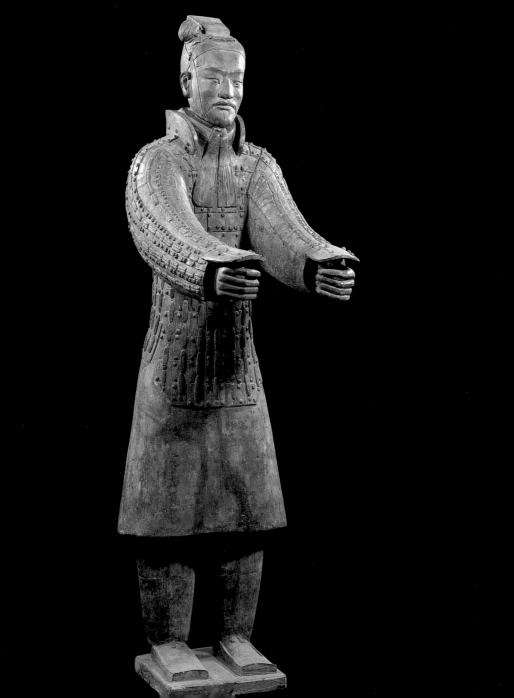

CHARIOTS AND CHARIOTEERS

Chariots, together with infantry and cavalry, were vital in warfare. Remains of about 130 chariots have been excavated from the pits of the terracotta army, constructed in wood with bronze fittings and a door at the back. This charioteer would have stood in the middle of the chariot, with his arms and hands as well as his chest and abdomen protected by armour as he drove. He also has extra protection around the neck. His hands are clasped as he holds the reins out in front of him. He would have been accompanied by charioteers on either side, each equipped with dagger-axes or halberds. The bronze half life-sized chariot drawn by four horses (illustrated overleaf) is one of a pair excavated from a pit to the west of the First Emperor's tomb mound and was designed for him to use to tour his empire in the afterlife. It can be seen from this chariot that the Qin had improved chariot design by reducing the size of the wheels and increasing the number of spokes, thereby increasing the stability of the vehicle.

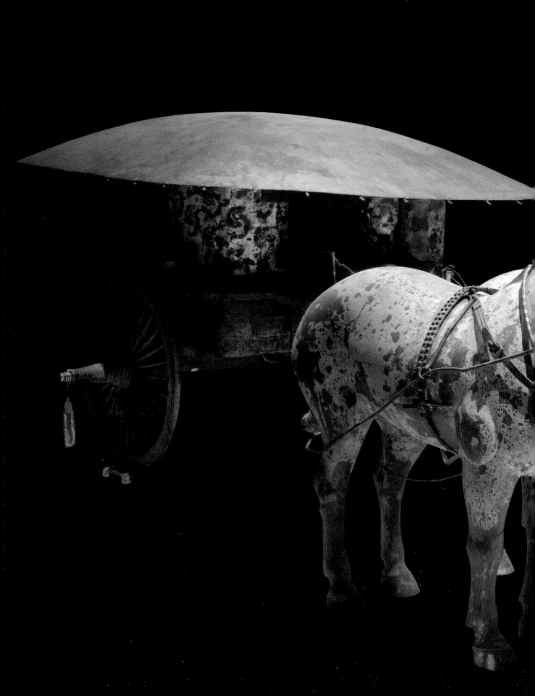

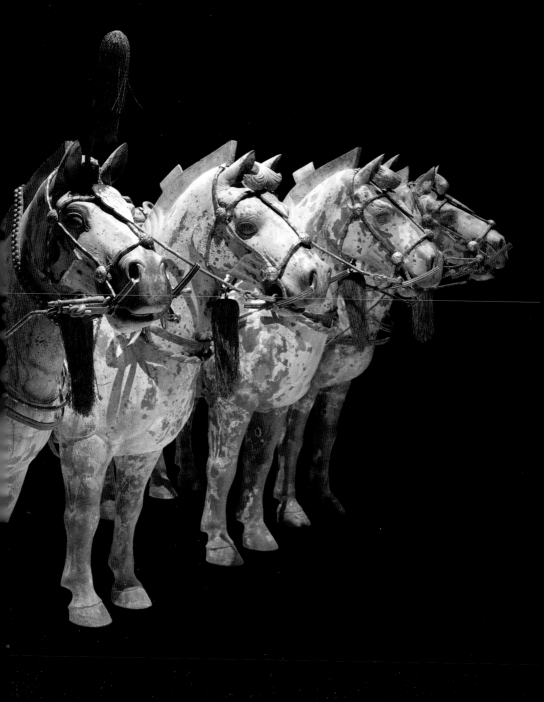

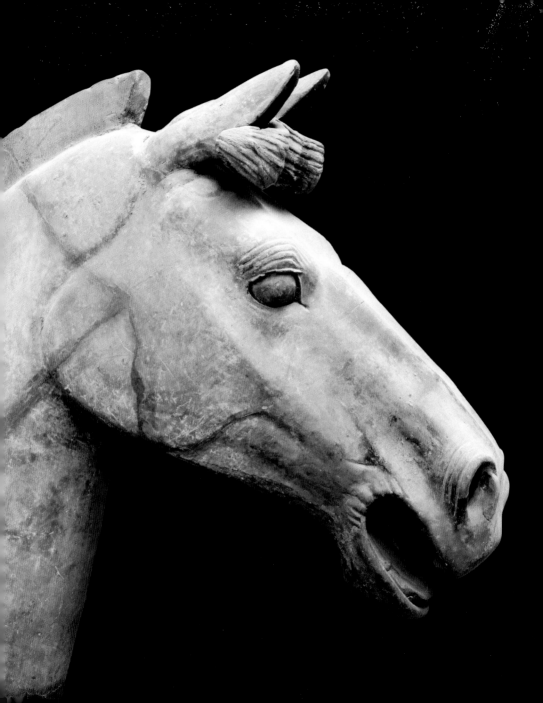

HORSES

Two kinds of horses can be found in the pits: chariot horses are unsaddled or bridled; while cavalry horses have terracotta saddles and were dressed with bridles made of bronze, which were fixed onto the horse after firing. The horses are hollow and were made of slabs of clay. They had a firing hole in the side that was closed up with a clay plug after firing. Traces of paint show that the horses were once painted in shades of brown, the saddles painted red and the leather straps picked out in white. Chariot horses have tails that are braided rather than tied up in a knot. The horses represented in the First Emperor's tomb complex are the native Chinese horse, as opposed to the swift horses from Ferghana in Central Asia which were discovered and imported during the following Han dynasty. The former are small and stocky; about 12 hands (125 cm) high at the withers.

OVERLEAF
View of Pit 3, the Command Post. The command chariot (missing) is pulled by four horses and driven by a charioteer.

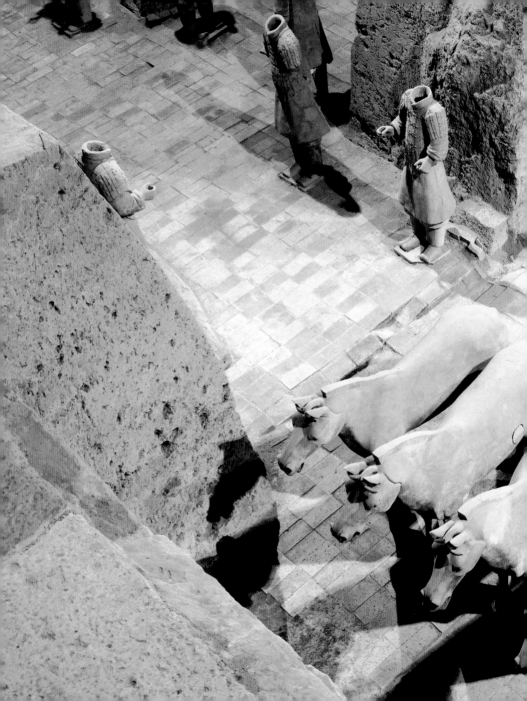

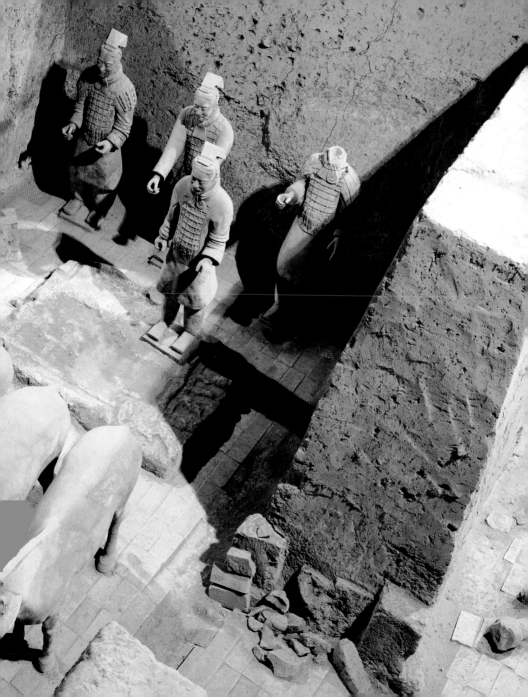

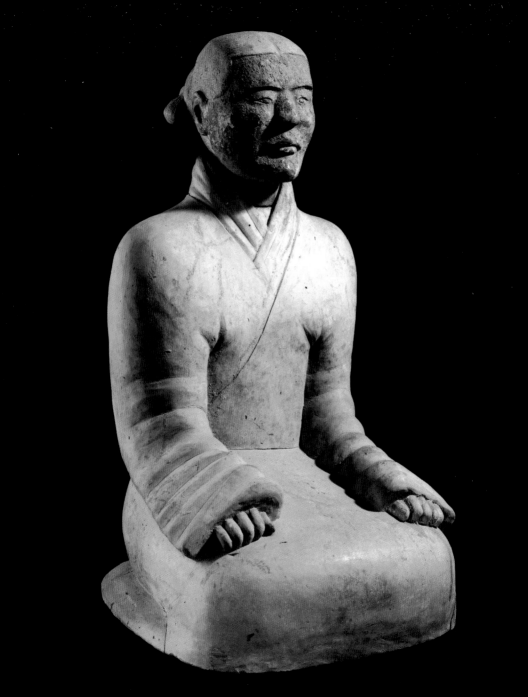

STABLE BOY

This kneeling stable boy or groom is one of a group of figures found together with horse skeletons in several hundred pits to the east of the outer wall of the tomb complex. It is thought that these pits represented the imperial stables. The figures are smaller than the fully grown warriors, at only 68 cm in height. When first discovered, they were mistaken for women, but traces of moustaches on their faces were later found during conservation and restoration work.

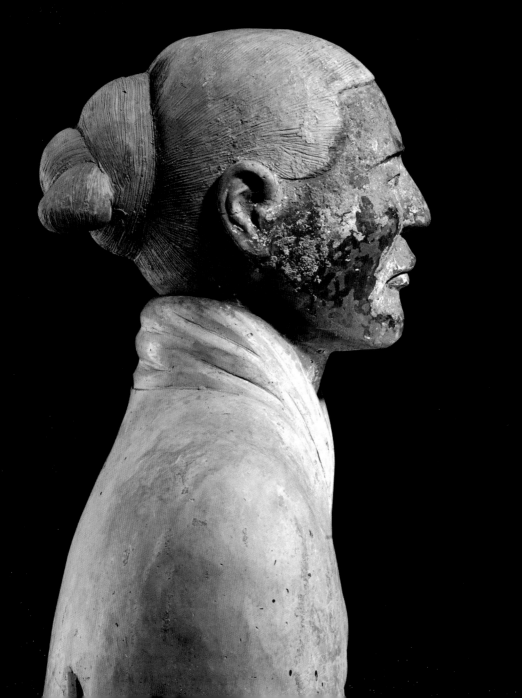

Profile of stable boy. His hair is drawn into a simple bun at the back of his head.

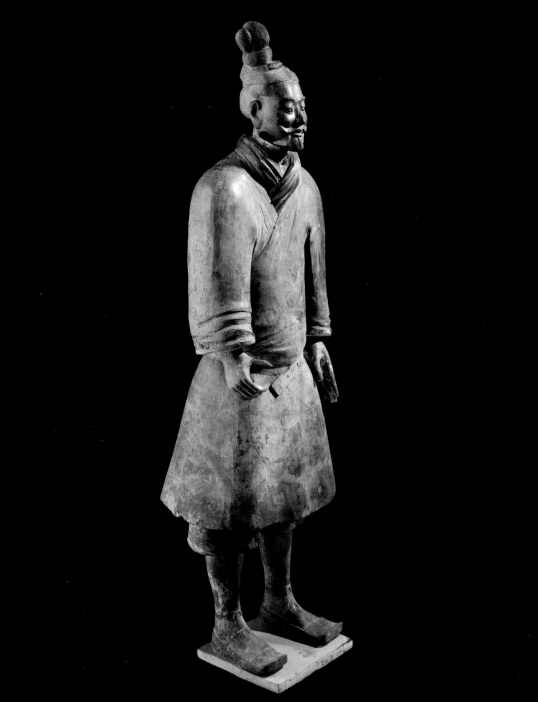

LIGHT INFANTRY

The light infantry were part of the advance guard. They wore long tunics, short trousers and puttees, allowing them to move more swiftly than the armoured infantry, and carried crossbows or long-range weapons. Their belts were decorated with stamped or painted diamond patterns and the belt hooks were also decorated. This terracotta infantryman from Pit 1 has his hair plaited and tied up in a topknot. His large nose and full and thick beard suggest that he may represent a minority people in the north-west border region of China.

OVERLEAF
Details of light infantryman.

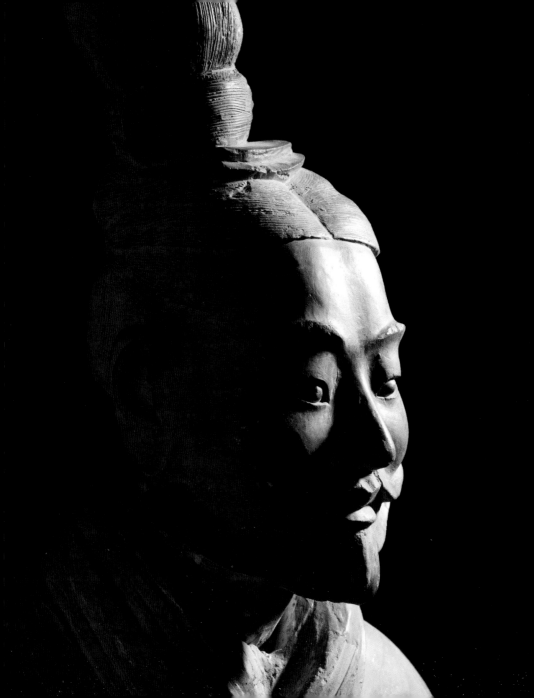

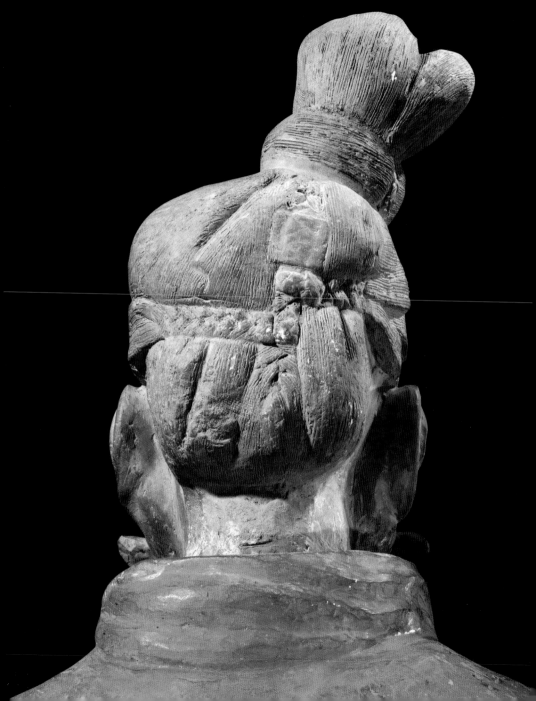

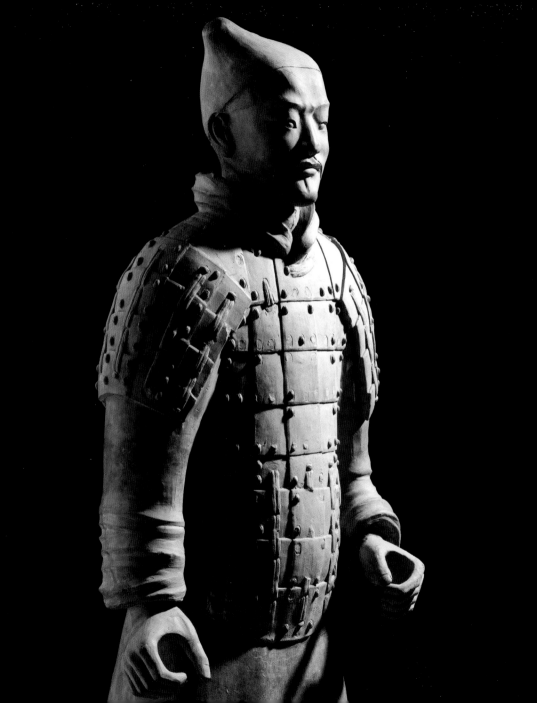

HEAVY INFANTRY

Most of the soldiers excavated from Pit 1 are heavy infantry. They were arranged in battle formation in rows of four behind chariots and armed with crossbows, halberds, poles or swords. This infantryman has a long tunic and the large plates of his armour cover his chest, abdomen and shoulders. His right hand is clasped around a lost weapon. He wears a soft cap over his tilting topknot, which can be tightened by a string at the back of the neck. His profile shows a typical Chinese shape.

OVERLEAF
Details of armoured infantryman.

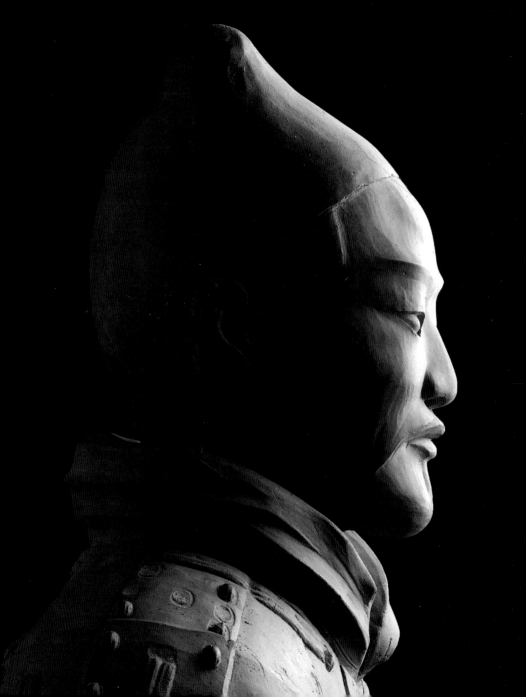

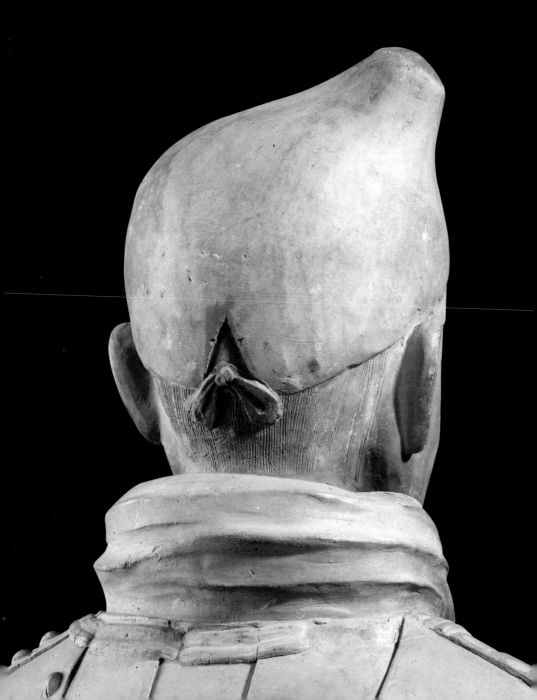

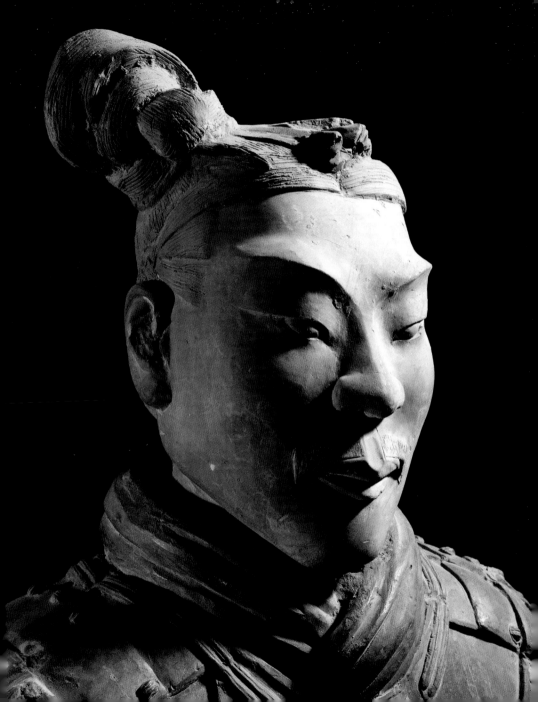

Another armoured infantry figure from Pit 1. The sculptural portrayal of the details of this face is very pronounced.

OVERLEAF
View of rows of armoured infantry in Pit 1.

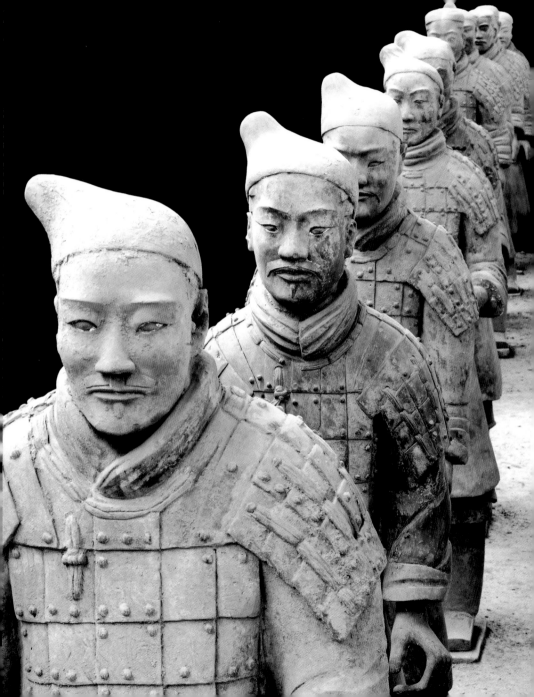

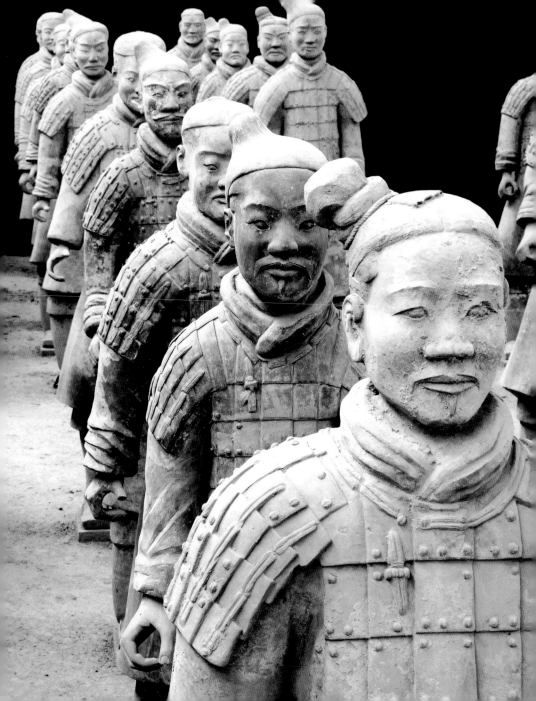

ARMOUR

Reconstructed set of limestone armour excavated from Pit 9801 to the south-east of the First Emperor's tomb mound. This pit, which has so far been only partially excavated, is thought to represent an armoury for the afterlife, as stone armour would have been of no practical use against weapons of bronze – it would have shattered on impact. Copying lacquered leather armour, this set is made of 612 pieces and weighs 18 kg. The overlapping stone plates are joined together with flat copper strips, threaded through holes drilled in the stone. The sets of armour were either on wooden stands or suspended from wooden beams in the pit.

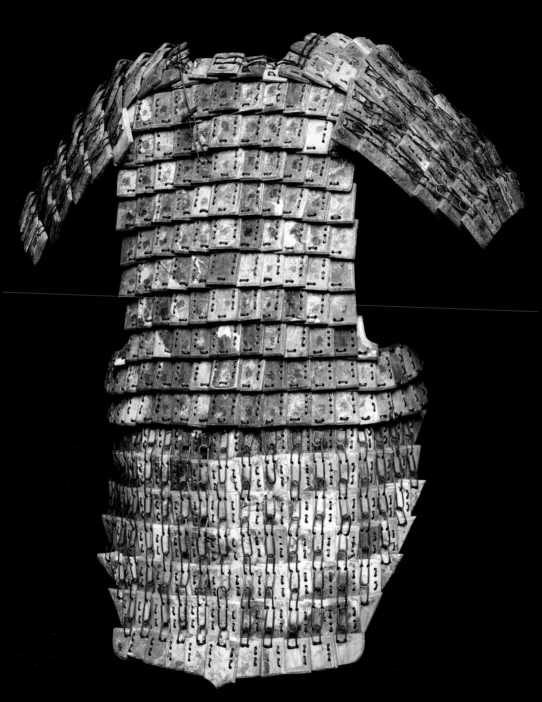

HELMET

Reconstructed stone armour helmet. Since the terracotta army wore no helmets, this stone example is a valuable source of information about helmets of the Qin period. It is similar to the design of the helmet part of the jade suits made in the following Han dynasty (206 BC–AD 220), and it is therefore thought that the stone armour may have been a precursor of the Han-dynasty jade suits; both were designed for protection in the afterlife. The fact that more stone armour parts have been excavated than helmet parts suggests that only approximately half of the sets of armour would have included a helmet. Horse-armour parts made of limestone have also been discovered in this pit.

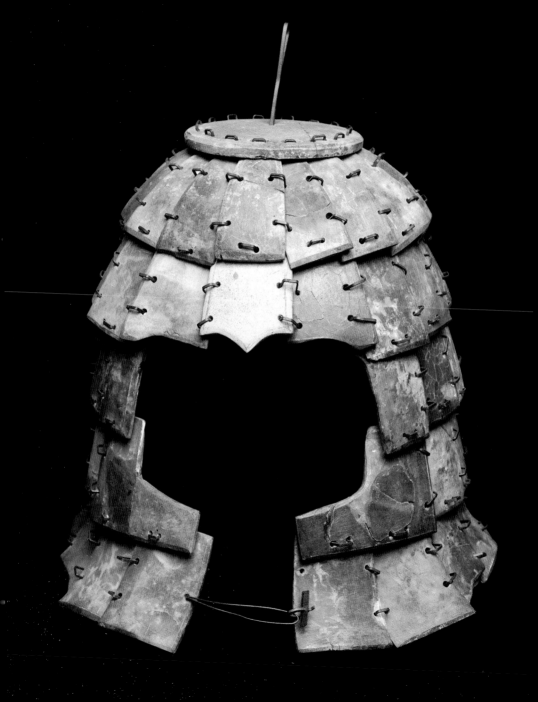

RIGHT
These three figures show the
differences in types of armour.
The general on the right has
longer armour with an extended
flexible pointed flap at the front;
the infantryman in the centre
has armour covering his torso
and shoulders; while the
cavalryman on the left has only a
short, sleeveless vest of armour.

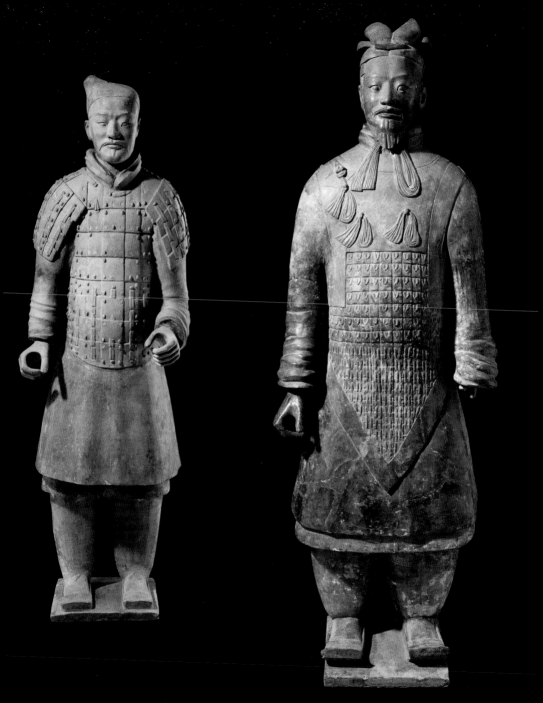

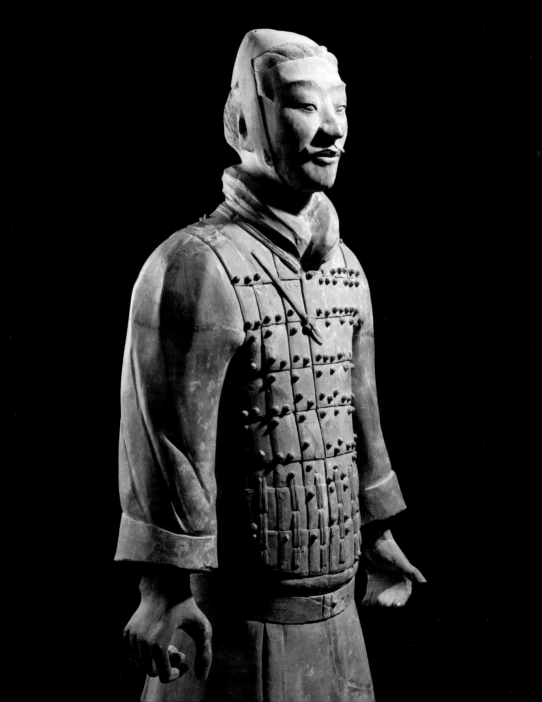

CAVALRY

In using cavalry and mounted archers, the Qin adopted the practice of the nomadic tribes to the north-west. This contributed greatly to their military supremacy over other states and to their ultimate success. Cavalrymen had a distinctive costume consisting of short, sleeveless armour that only reached the waist, which gave them flexibility and mobility. They wore thickly padded knee-length tunics, long trousers and leather boots, all for protection. Their flat caps with leather chin straps are also unique to the cavalry. The colours of the costumes of cavalrymen varied, suggesting that they did not have a uniform. The varnished belts were decorated with geometric patterns and had belt hooks. This cavalryman excavated from Pit 2 has a large nose and thick moustache. His finely combed hair is neatly plaited and pinned up under his riding cap.

OVERLEAF
Details of cavalryman.

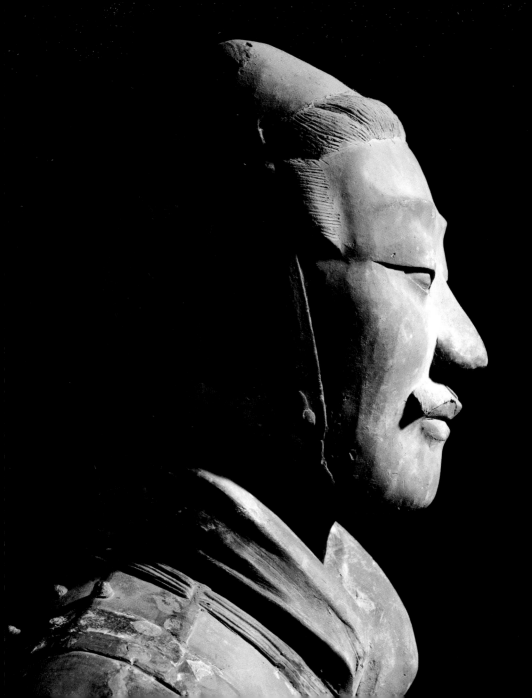

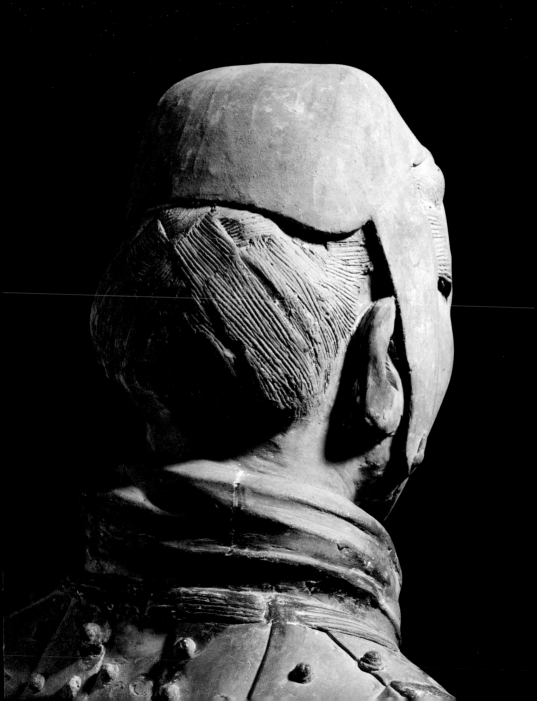

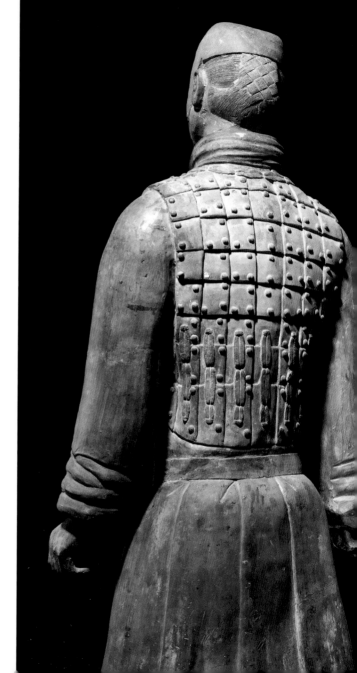

RIGHT
Cavalryman leading his horse
by the reins with his right
hand. His back was fully
armoured for protection as he
rode. The horse's bridle was
made of bronze, but its
cushioned saddle and the
leather straps around its girth
were fashioned in terracotta.

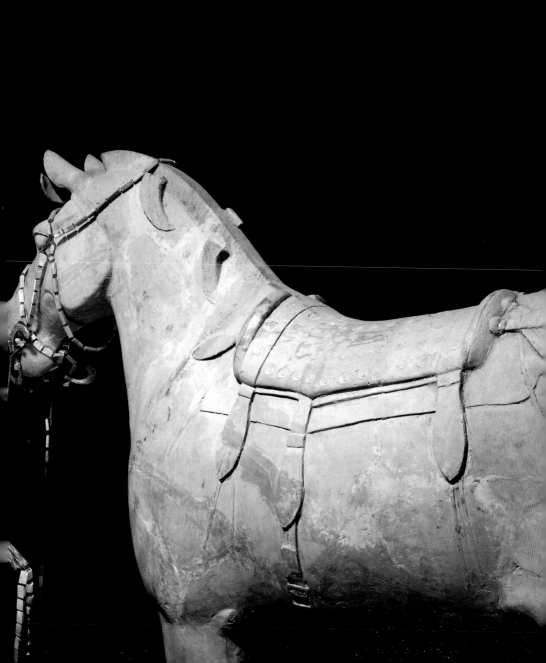

CIVIL OFFICIALS

The discovery of officials as well as warriors shows that the First Emperor wanted a civil administration to run his afterlife empire as well as an army to guard him. The officials are unarmed and wear elaborate hats with ribbons tied under the chin. Their costumes consist of long padded robes, tied to one side across the chest, and long padded trousers; neither seems designed for mobility. On their belts hang knives and a knife sharpener, also fashioned in terracotta. The knives are for erasing mistakes on documents written on rolls of wooden or bamboo strips before the use of paper. This figure is one of a group of eight excavated in 2000 from a pit to the south-west of the tomb mound.

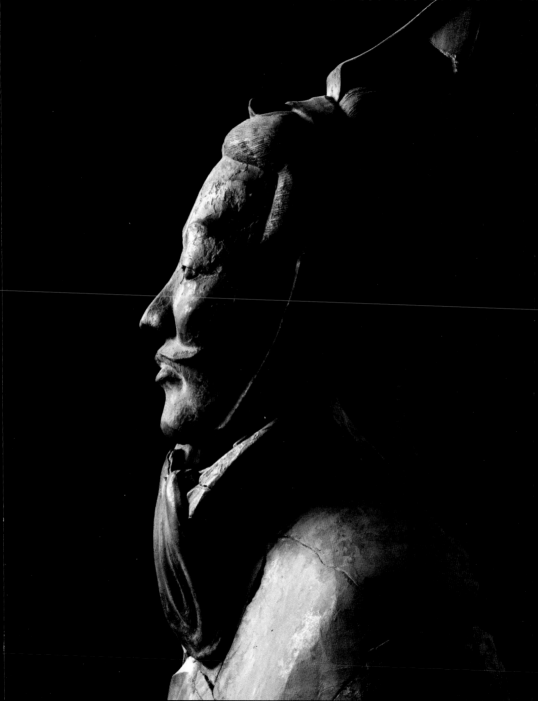

RIGHT
This bureaucrat's official hat is tied in front of the
ears and fits on top of a flattened French-roll
hairstyle. His hands are hidden under long sleeves.

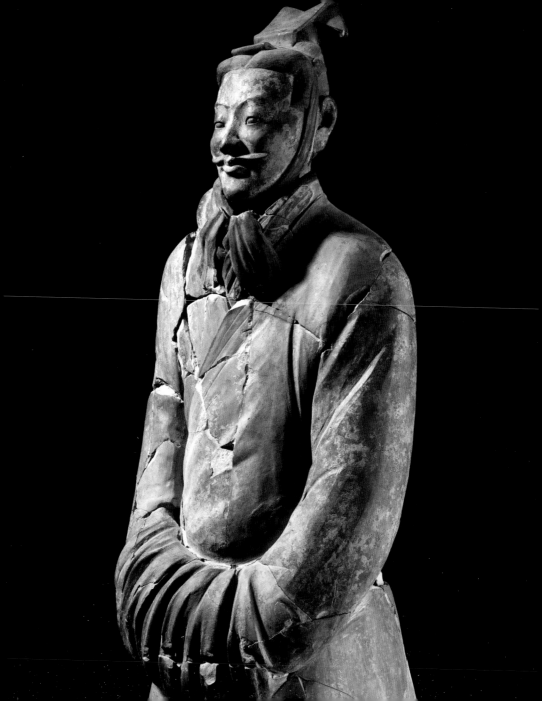

ACROBATS

This acrobat was excavated from a pit to the south-east of the tomb mound in 1999. Designed to entertain the First Emperor in the afterlife, he seems to be doing a balancing act by spinning something on his right index finger, which has a hole in it. He wears a short skirt and balances on one leg as if he has just completed a trick. Twelve life-size acrobats were found together.

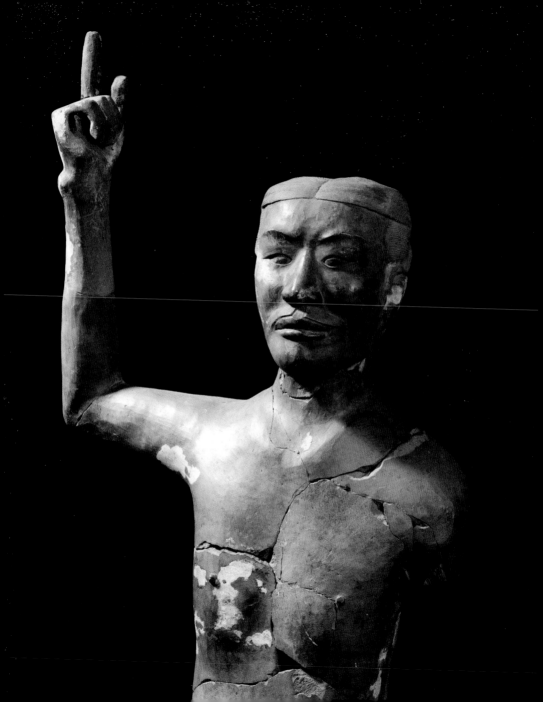

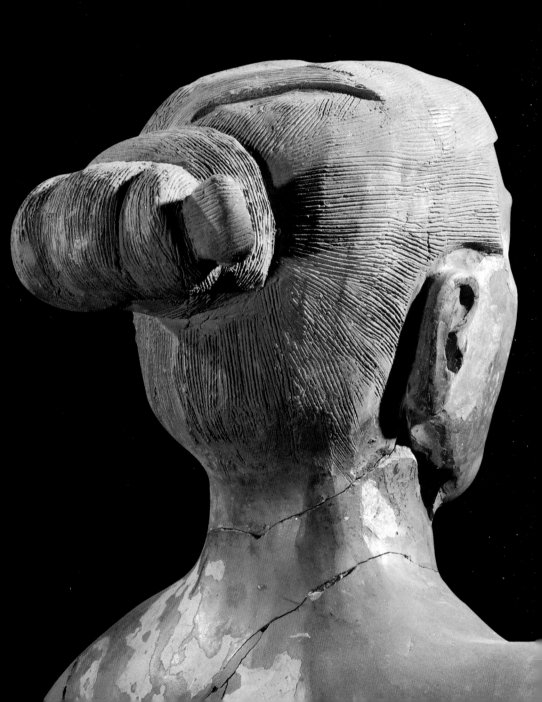

**Detail of a young acrobat. His hair is fixed tightly on the back
of his head to enable maximum mobility and flexibility.**

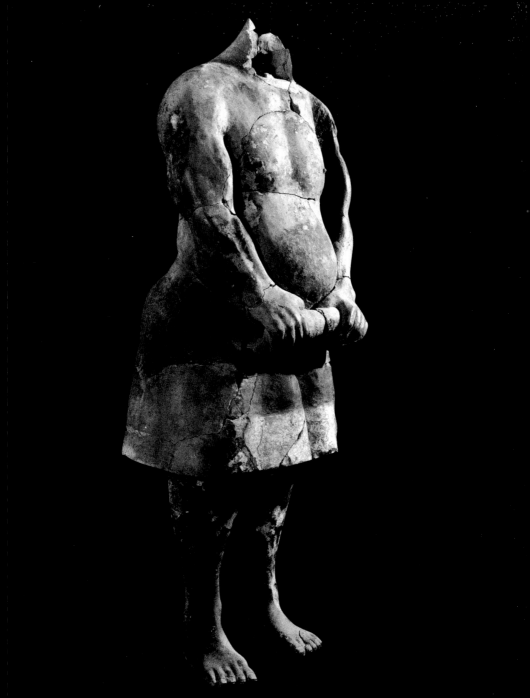

STRONGMAN

This strongman was found in the same pit as the acrobat. His large hands grip a weight, suggesting that he was a weightlifter, also designed to entertain the First Emperor in the afterlife. His highly developed muscles can be seen clearly on his arms and shoulders, while his belt acts as a support for his substantial, protruding stomach.

MUSICIANS AND BIRDS

Terracotta musicians were excavated in 2001 from a pit in the north-east
of the tomb complex where they were found with bronze water birds by
an underground stream. Chinese archaeologists suggest that the musicians
were playing to the bronze birds, which were trained to dance to the music
in order to entertain the emperor. This kneeling figure was possibly playing
a percussion instrument, such as a bell or drum, as he seems to be holding
a mallet or hammer as if about to strike something. All the musicians
are dressed in long wrap-over robes and trousers, flat soft caps and soft
slipper-like shoes.

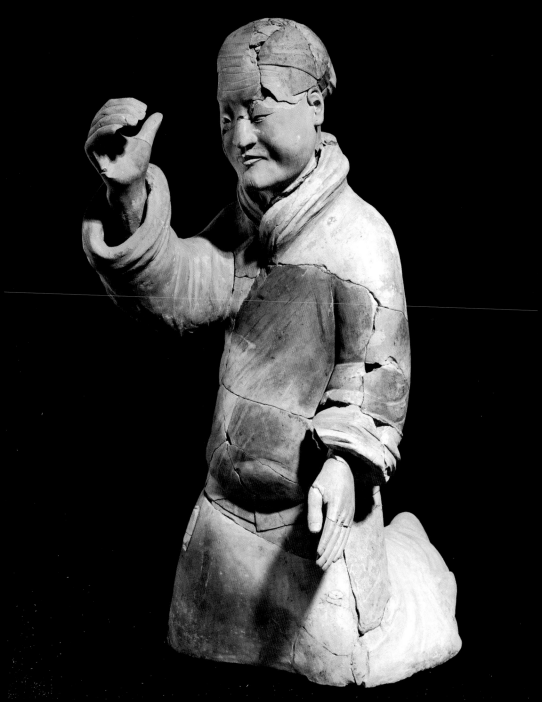

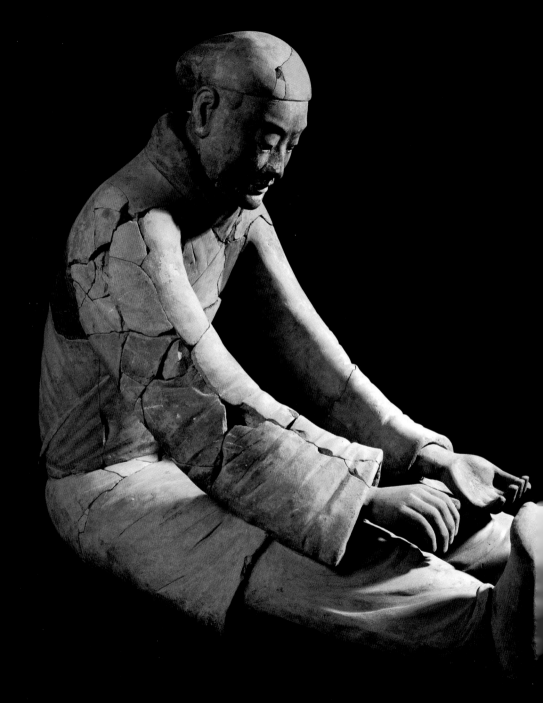

A seated terracotta musician, also found with the bronze birds. His long stretched-out legs and the position of his hands suggest that he was plucking a flat stringed instrument similar to a zither.

This realistic bronze crane was found in the underground stream. It has painted feathers and holds a worm in its beak.

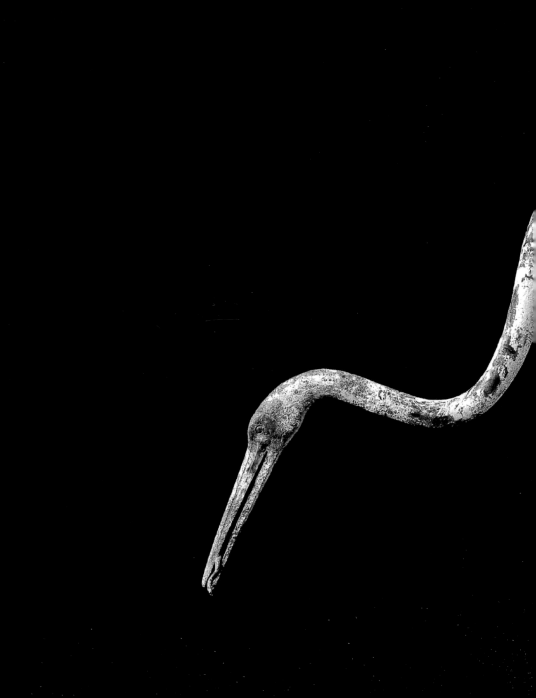

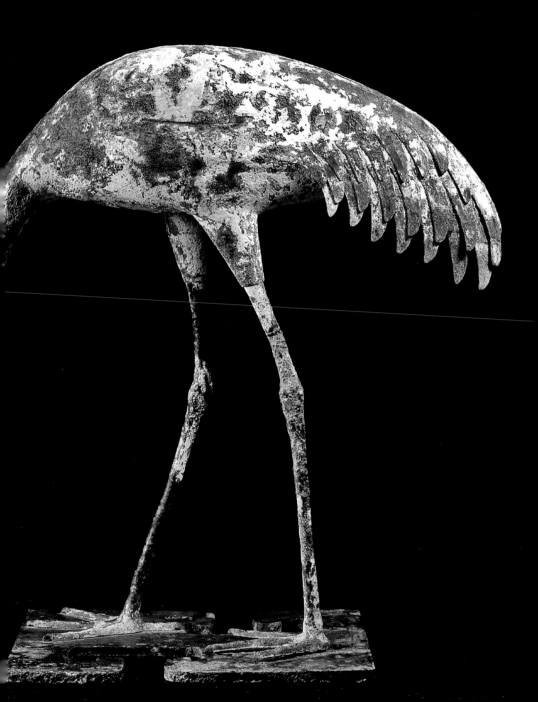

FURTHER READING

The following list is intended as a guide for those interested in pursuing the subject further using Western languages, with an emphasis on books that are still available in bookshops or libraries. Books in Chinese are not included, neither are articles in specialist academic journals. References to these can be found in the bibliographies of many of the books cited here.

Blansdorf, C., Emmerling, E., Petzetet, M. et al. (eds) (2001). *Die Terracottaarmee des Ersten Chinesischen Kaisers Qin Shihuang*. Munich.

Bodde, D. (1938). *China's First Unifier*. Leiden.

Bodde, D. (1987). 'The State and Empire of Qin', in Twitchett and Loewe (eds) (1986), pp. 20-98.

Bonn Exhibition (2006). *Xi'an, Kaiserliche Macht im Jenseits, Grabfunde und Tempelschätze aus Chinas alter Hauptstadt Mainz*.

Chang, Kwang-chih and Xu Pingfang et al. (2002). *The Formation of Chinese Civilisation: an Archaeological Perspective*, Sarah Allen (ed.). New Haven and London.

Hearn, M. (1981). 'The Terracotta Army of the First Emperor of Qin (221–206 BC)', in *The Great Bronze Age of China*, Wen Fong (ed.). New York.

Hulsewe, A.F.P. (1985). *Remnants of Ch'in Law*. Leiden.

Kern, M. (2000). *The Stele Inscriptions of Ch'in Shih-huang: Text and Ritual in Early Chinese Imperial Representation*. New Haven.

Ledderose, L. and Schlombs, A. (1990). *Jenseits der grossen Mauer – der Erste Kaiser und seine Terracotta-Armee*. Munich.

Ledderose, L. (2000). 'A Magic Army for the Emperor', in *Ten Thousand Things – Module and Mass Production in Chinese Art*. Princeton.

Lewis, Mark Edward (2007). *The Early Chinese Empires: Qin and Han (History of Imperial China)*. Cambridge, Mass.

Li Yu-ning (1977). *The First Emperor of China*. New York.

Michaelson, C. (1999). 'Qin Shi Huangdi and His Terracotta Army', in *Gilded Dragons*, pp. 32–42. London.

Paludan, A. (2006). *Chinese Sculpture*. London.

Portal, J. (ed.) (2007). *The First Emperor: China's Terracotta Army*. London.

Rawson, J. (ed.) (1992). *The British Museum Book of Chinese Art*. London.

Rome Exhibition – Lanciotto L. and Scarpari M. (2006). *Cina: Nascita di un Impero*. Rome and Milan.

Twitchett, D. and Loewe, M. (eds) (1986). *The Cambridge History of China*, vol. 1. Cambridge.

Watson, B. (1993). *Records of the Grand Historian; Qin Dynasty*. Hong Kong.

Wu, Hung (1995). *Monumentality in Early Chinese Art and Architecture*. Stanford.

Wu, Hung (2005). 'On Tomb Figurines – the Beginning of a Visual Tradition', in Wu Hung and Katherine R. Tsiang (eds), *Body and Face in Chinese Visual Culture*, pp. 13–47. Harvard.

Yang, Hsien-yi and Yang, Gladys (1974). *Records of the Historian*. Hong Kong.

ACKNOWLEDGEMENTS

Photographs on pp. 14 and 42 © the Shaanxi Cultural Heritage
Promotion Center

Photographs on pp. 8 and 18–19 by John Williams
© The Trustees of the British Museum

All other photographs by John Williams and Saul Peckham
© The Trustees of the British Museum, with the kind permission
of the Shaanxi Cultural Heritage Promotion Center